Joie de Vivre

How to Deal With the Effects of Post-Traumatic Stress Transculturally

DR. ERNANDE"ANNA"FORTUNE CHERUBIN, PhD

WestBow Press books may be ordered through booksellers or by contacting:

WestBow Press
A Division of Thomas Nelson & Zondervan
1663 Liberty Drive
Bloomington, IN 47403
www.westbowpress.com
1 (866) 928-1240

Because of the dynamic nature of the Internet, any web addresses or links contained in this book may have changed since publication and may no longer be valid. The views expressed in this work are solely those of the author and do not necessarily reflect the views of the publisher, and the publisher hereby disclaims any responsibility for them.

Any people depicted in stock imagery provided by Getty Images are models, and such images are being used for illustrative purposes only.
Certain stock imagery © Getty Images.

ISBN: 978-1-6642-0351-8 (sc)
ISBN: 978-1-6642-0352-5 (e)

Library of Congress Control Number: 2020916467

Print information available on the last page.

WestBow Press rev. date: 10/15/2020

DEDICATION

I would like to dedicate this book to anyone who has endured a loss or is going through a rough patch in their lives, and I would like to thank God for granting me this opportunity to write and share this book. A special thanks to my husband, Frantzy Cherubin, who is always supportive in my endeavors. I would also like to thank all my friends and family who have always been there for me through prayer, encouragement, and motivation.

CONTENTS

Dedication...iii

Preface ..vii

1. The Big Shock..1

2. The Caregiver ...11

3. Trauma-Informed Person Support and Recovery21

4. Reclaiming the Joy to Live ...33

5. Conclusion ...44

Resources: Suggested Reading..50

PREFACE

One evening, I was sitting with my husband when I received a text message from someone.

"Is he OK?" the message read.

Of course my husband is OK, I thought. *He's sitting right here, smiling, as usual.*

A new message appeared.

"Check what he wrote on social media."

I opened up the page to my husband's social media account. My husband had recently posted, "Son, see you soon."

I knew what this was in reference to. My husband's son had been shot to death in 2018. I was struck by this dissonance: my husband was in the same room with me, smiling away. Yet his social media account revealed what was beneath his smiling surface.

Although he had been going about his day-to-day life, performing his job as a nurse to the best of his ability, there were small clues here and there, such as this one, that he was struggling a great deal more than he let on. I recalled that during a trip to France, he had even confided in someone that he'd lost his *joie de vivre*, his joy of living.

Over the years, I've experienced many inexplicable tragedies—tangentially, through the tragedies of others, as well as my own—and I've gained a lot of insights into the role that trauma plays in our lives. On one hand, my educational and professional background in healthcare has led me to approach trauma-related topics from an analytical perspective. As a nursing home administrator, I've witnessed many deaths and have cared for all kinds of patients, and I've also served as a mentor, training new professionals in the field. On a personal level, I've been through the loss of a parent, cared for my first spouse while he battled cancer, and suffered through many family members' and friends' transitions to heaven. Each time, God has brought me through it, and I've been able to find my *joie de vivre* again.

But I'm lucky. Most of us will be touched by trauma over the course of our lives, and the emotions we experience when we're at our most vulnerable have the potential to bring us together... if we can learn to cope and express ourselves in healthy ways. But many people, I've found, don't know how to open up about their struggles.

There are many reasons for staying silent. People may be afraid to share. They may not know how to share. Or they might feel pressured to "keep on a happy face," worrying their problems may burden others. While grieving the loss of his son, my husband has kept the majority of his pain silent. At work, he's learned to turn his emotions off, feeling an obligation to be professional no matter what adversity he faces. As a professional in a caregiver field, I have a tendency to stay professional, myself—not wanting to burden even my closest loved ones with the weight of my pain.

But of course I have my own pain and problems. All humans do. The truth is, we simply never know just by looking at someone what they're going through.

This book is for anyone interested in a closer look at the journey from trauma back to joy—whether you have suffered yourself, work with individuals recovering from trauma on a professional level, or are caring for a loved one in recovery. In it, I'll help readers: define traumatic-informed care symptom criteria and specific psychodynamic and behavioral interpretations to be considered in understanding the loss of joy to live; learn factors

enhancing or inhibiting emotional responses, whether physical, chemical, or psychological; develop a quick awareness of a person's feelings and actions that may indicate post-traumatic stress disorder; and appreciate the role of multidisciplinary teams and learn to make appropriate recommendations to other health care professionals, spiritual leaders, employees assistance program (EAP), etc. I'll also explore the complicated role of the caregiver, helping readers understand some of its greatest rewards and risks, with the goal of promoting self-care.

Although it relies on my educational background and professional experience, this book takes less an academic or business-centered route through trauma care than it does a personal one: it is also the story of me and my husband, and I hope that by sharing about some of our own journey, readers will see what can lie beneath a smiling, or silent, surface.

In particular, gunshot violence tends to be a taboo or off-limits topic, and I'd like to change that by writing about it, so that readers may feel more comfortable discussing their own individual trauma with others, too.

Finally, I'd like to share what "joy" means to me, as well as some of the things I've found most helpful in walking the path from trauma back to health and happiness:

1. Stay busy.
2. Express yourself in whatever way works best for you.
3. Stay strong in your faith, whatever it may be.

How can you help someone who pretends to be happy, but is quietly dying on the inside? How can you give everything you have towards helping a loved one through a problem while maintaining your own health at the same time? How, in the midst of life's calamities, can we regain the joy of living? These are the questions this book addresses.

When I told my husband I planned to write this book, I shared with him what the title was going to be: the words he hadn't been able to say to my face, but had shared with someone else, and had also hinted at through social media. His *joie de vivre*.

"You're going to write our story?" he asked, brightening.

I hadn't seen that light in his eyes for a long time. It was as though the very idea of expressing himself with others, in a way that he was comfortable with, sparked some small hope from within.

This is the underlying goal of this book: to bring some hope to anyone suffering in silence within their culture because they're holding in their pain or masking it. Don't keep your pain inside. Express it, and you're on your way to regaining your joy of living.

1

THE BIG SHOCK

It is possible that I was born a caregiver, or, rather, that I've been drawn towards caregiving since I was born.

I'm originally from Port-au-Prince, Haiti, where I was fortunate to have a happy life. I was brought to and from school by drivers, and I had freedom and independence. At the age of eight, my family moved to South Florida in the U.S., where I attended elementary through high school. There, our lives became a bit different. We were on more of a budget for living, and I didn't have as much autonomy as I was used to.

Instead of doing some of the things typical among other girls my age, such as sitting indoors and playing with dolls, I spent my spare time playing "teacher," helping other children understand things and offering support. Perhaps these were the first flickering signs that I would dedicate so much of myself to caring for others.

As a teenager, while working at a shopping mall in Florida, I made a decision that would set the course for my path in life. I signed up to volunteer at a nursing home. It brought me great joy to be there for people during rough patches, and when it came time for me to pursue my education and select a course of study, I followed my interests and graduated from Florida State University with a Bachelor's of Science degree in psychology.

I went on to Lynn University in Boca Raton, Florida, where I earned a Master of Science in Healthcare Administration. Upon licensure, I focused my attention on the skilled nursing

and long-term care industry, where I've gained a solid knowledge of the healthcare industry. I've been working in FHCA member facilities for over twenty years, and I'm proud to have worked in facilities whose achievements have been recognized through awards and by rankings in *The US News and World Report*. But my career in this industry truly began when I worked as a home health aide and nursing home volunteer. For self-actualization, I decided to pursue a PhD in Corporate Leadership and Organizational Management at Lynn University, and I graduated in 2009.

Then, on a summer night after attending a funeral, I was introduced to a very kind man from Tennessee—almost *too* kind. Every other word he spoke seemed to be, "I'm sorry."

"That's how we express ourselves in Tennessee," he explained.

He had worked as an accountant for years before deciding to switch to nursing, freeing him to work anywhere in the world. Through about five minutes of chatting, I must have made quite the impression on him, because as soon as he found out that I was single, he said, "I'm going to take you off the market."

This man, who became my husband, transitioned to living in Florida ever since; and he now has those same words to me inscribed on his wedding band.

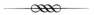

My husband has always had one of those full-of-life personalities: speaking his mind; greeting the world with an open, trusting heart; and filling the room with his emotions. Although his main career has been in nursing, for a while, he became inspired to start his own radio show, which he would broadcast straight out of our home.

He created it from scratch but developed it to a point where it was professional and successful. He'd thoroughly research and select his topics and hold detailed interviews with topical guests. Tons of listeners would tune in. The radio show, called *Radio de famille* ("the family radio"), was also a way for him to express himself, to unwind, and most importantly, to educate people—all without leaving the house. It was a kind of

creative refuge for him that allowed him to form many meaningful connections with others in the community.

One night, while preparing for a show, he was debating between two topics to cover. One was the story of a girl who had been reported missing in the Dominican Republic. The other was a topic raised by a previous caller, a woman whose son had been shot to death, posing the question: *if your son was shot, would you be able to forgive the person who killed him?*

He strongly considered choosing this second topic, but at the final moment, changed his mind. The girl from the Dominican Republic had been found, after all, and he wanted to share with his listeners the followup—the happy ending—from her story.

While he was in the middle of producing his radio show, he received a phone call. I'll never forget the expression on his face as the life visibly drained out of him.

This was in April of 2018. My husband's son had gone out to purchase a cell phone from someone he'd connected with on a selling app, and the seller had shot him. My husband's other two children were in the car with him, but thankfully, they weren't injured. It appears the seller's intention had been to simply rob them, but instead, he wound up shooting my husband's son through the head, taking his life. He was seventeen years old.

Even in today's world of gun violence, no one expects to get the big shock of gun violence knocking at their own door until it does. I've seen close family members battle cancer, diabetes, and Alzheimer's, and even die of accidents. But having someone die of gun violence is on a level of its own. It is sudden, surreal, and devastating. As a professional with a degree in psychology and as a faithful servant of God, I have promoted counseling, scriptures, Employee Assistance Programs (EAP), and prayer to help my spouse through the pain that he continues to struggle with, all the while he pretends to be OK.

But when I began to realize the extent to which he was suffering over this tragedy, I was devastated, myself. Why? Because no one ever wants to see anyone they love unhappy,

especially when they seem hopeless. Although he maintained a polite exterior, the loss of his son had, in fact, changed him in many ways. He used to be an open and friendly person, quick to trust strangers and unconcerned about practical things, like making sure the car door was locked. He had an overall sense of security in the world and never suspected something so terrible could happen.

This is the quality I saw change the most in him; it was like night and day. After the gunshot incident, he began worrying about our safety, growing concerned over strangers and seeming reluctant to leave the house. He seemed too anxious to purchase things online, and although we hadn't used selling apps before, it was suddenly clear that he didn't want anything to do with purchasing things via the Internet, especially not from a stranger. Sometimes, well into the night, I'd catch him wiping tears from his eyes when he must have thought that I was sleeping, perhaps his loneliest hours. What he didn't realize was that I was there with him, that even through the darkness, I could see his tears.

I believe there's a lesson to learn from this tragedy, which is that we must continue to fight against gun violence as we thank God for the life that He allows us to see every day, for the blessing that we are still breathing. From my perspective, only God can give us the joy to live throughout life's circumstances, and we must be willing to live to continue our mission on earth.

Regardless of your personal beliefs, faith, or culture, we all must face the fact that mental health issues, such as post-traumatic stress disorder (PTSD) and depression, are real and present among all kinds of individuals, worldwide. In our darkest hours, we often feel so alone that we cannot imagine there are others suffering as much as we are, but nothing could be further from the truth.

Although it is widespread, the actual experience of trauma is unique to everyone. "Transcultural" is defined as "how people act as members of different cultural or national communities" (Merriam Dictionary, 2019). Individuals deal with sensitive and often painful issues with life experiences, but there's a specific resource that enables clinicians to diagnose and treat a patient presenting with trauma and post-traumatic stress disorder,

as defined in DSM-IV-TR. This category of mental disorders indicates a psychological disturbance in emotional function.

When we talk about "trauma," some things that tend to come to mind are sexual or physical assault, death of a loved one, or natural disasters. Generally speaking, however, individual trauma is simply caused by any event(s) or situation that comes with long-lasting and adverse impacts on one's well-being. This can include difficulty in functioning on a mental level, a physical, social, or emotional level, or even simply on a spiritual level.[1] And, since each person brings to trauma his or her own unique sets of perceptions, judgments, and coping methods, "trauma" looks and feels different to every person experiencing it. What feels like a bearable amount of stress to one person may feel extremely traumatic to another.

To a large extent, a person's response to his or her trauma is shaped by the broader, external sphere: how their family, community, and culture perceive and react to trauma. Many communities misunderstand, dismiss, or stigmatize the role of trauma in individuals' lives, which can create barriers to healing or even act as a new form of trauma in and of itself.[2] Although many cultures define and experience trauma in their own ways, and while there are traumas that affect groups and entire communities, this book focuses on trauma and joy as they relate to individuals.

With such varied experiences and responses, however, how can we, as caregivers, best help another person with his or her struggle?

1. Acknowledge their need for help
2. Be persuasive and offer professional help as needed
3. Approach support transculturally, based on the individual's upbringing and beliefs
4. Pray, pray, pray
5. Encourage them
6. Love them
7. Listen to them
8. Have faith

[1] NYCU - Jan 2020 - Combined Handout _ Questions
[2] NYCU - Jan 2020 - Combined Handout _ Questions

One of the simplest and most important things we can do is be present for those suffering. Be by their side, and tailor your support to their needs: motivating them when they need energy, encouraging them to connect with others when they feel isolated, or giving them permission to retreat when feeling crowded or stifled. This is all about creating a space where they feel they can express their feelings in whatever way is healthiest for them.

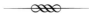

What if you don't know exactly what a person needs to feel better? I admit, this can be a challenge, especially when so many of us have learned to keep our pain hidden within. When in doubt, I cannot overstate the value of simply speaking with others—whether they are patients or loved ones—and listening to them. Give them room to share their stories and describe their pain. Once people begin talking about their feelings, they tend to feel some relief from them, and little by little, you see a change come over them. It is as though, as the darkness of their pain rises to the surface, some light source from deeper within starts blinking back on again.

These are tiny glimpses of joy. For me, this is what trauma recovery is all about: tracing your way from that dark room of trauma we all find ourselves in from time to time towards the joy that is always there, even in our darkest hours. This is a message that I want to stress, that this is not a book about trauma, it is a book about coming back to life.

2

THE CAREGIVER

I'd been married and widowed, but now that I'd found the right person for me, my current husband and I wanted to start a family. On April 27, 2018, I had the greatest moment of experiencing an IVF transfer that was surreal and inexplicable. I'd been doing ultrasounds each day, preparing my body for a hopeful procedure. On April 30, 2018, when we learned that my husband's son had just been shot, this was the worst nightmare that a parent could ever live through, and immediately, my heart went out to my husband, leaving my own problems aside. I will never forget the thoughts of helplessness, speechlessness, and *how am I going to support my spouse in this time of sorrow and shock?* running through my mind. A silent prayer was the quickest thing that I could think to do to ask the Lord for strength and guidance, as we were about to cross the biggest bridge at that time.

Dear God, here I am as a caregiver going through my own struggles with infertility, miscarriages, and my own stress. Has anyone ever asked me how I feel? Well, I thank you for the foundation that you have provided me in faith to be able to make it through and to be able to stand strong for those who need me more than ever. Thank you for the joy to live. Amen.

After the two-week post-IVF treatment, we found out that the IVF was not a success.

Throughout my career in healthcare, I've had the privilege of supporting all kinds of patients and families. I've worked with people of all ages, whether they are long-term elderly patients suffering from debilitating conditions, such as strokes, or young people recovering from severe accidents or temporary injuries. The pain and depression that I've seen can be devastating. But, at the same time, I get to act as people's advocate: giving them a listening ear; navigating them through healthcare options and protocol; guiding them through making life-changing decisions; or simply making them smile.

Once, I helped a woman who was stuck in Florida obtain a plane ticket back to her home state of Ohio at a lower cost, juggling multiple phone calls at once and speaking with the airline on her behalf. It brings me a lot of satisfaction to be in a position to help people in this way, and many more. The kinds of facilities I've worked in are a home away from home for patients. And the staff that operates them are a temporary family for patients and their loved ones.

Besides, for as much suffering as I've seen, I've also been fortunate to witness a great deal of strength and gratitude. I've seen self-conscious patients refuse medication that could dramatically improve their health. But I've also seen patients come in connected to tubes, unable to swallow food, and eventually walk out of the facility and return to their normal lives.

At times, we've received former patients who have come back to volunteer, another sign that our work is meaningful. I feel privileged to be entrusted with people's wellness during times of such vulnerability, and playing a helping role in others' day-to-day lives is incredibly gratifying. Still, suffering is an undeniable component of the nature of this work. Sometimes, people ask me how I do it. For me, the answer is simple. I pray before I go in each day, and I pray when I finish work. I rest assured that my staff and I do everything we can for our patients, and that we're highly qualified for the profound work we do.

As a Haitian American woman, I've seen how some people in my community, church, family, have maintained their so-called strength, dignity, etc., for the sake of societal views; however, they are dying inside. In many cases, it's useful to inform the person that it's OK to feel the way they are feeling, and that you are here for them regardless.

It's far more challenging when you read the person's feelings on social media, and you are right in front of them, and the feelings are not expressed or communicated to you directly. That's when you wonder, *what is my purpose? Why didn't they reach out to me?*

Quite frankly, it was a blow to my ego: there I was, a caregiver in every sense of the word, and my husband didn't feel able to open up with me about his needs. However, it is what it is. If others are expressing themselves, letting it out and not holding it in, then that is a good thing. At least they are purging the negative energy so the healing can begin. Also, it's good to know that it's OK to carry the torch and do the good deed in order to continue the legacy of the loved one.

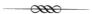

In order to successfully help those around us, we must first be mentally, physically, and spiritually healthy, ourselves. Another key way I've learned to be a good caregiver is by prioritizing my own needs. I'm not afraid to acknowledge my weaknesses or admit when I need help, myself.

This is a danger caregivers face: overextending ourselves. In our attempt to put all our energy and concern towards a loved one, we sometimes neglect our own needs. I've seen patients' loved ones putting all their time and focus towards making sure their loved one has everything they need, doing chores for them or running their errands, making their appointments and following up with their health insurance providers, making them comfortable, and spending time with them to lift their spirits and reduce their pain. It's a wonderful thing when patients' loved ones can be there for them, offering strength. This instinct comes from a heartfelt and generous place. And yet, when taken to an unhealthy extreme, it can shift so much of the caregivers' attention away from their own lives that they, themselves, become unwell.

In my previous relationship, when my partner was diagnosed with cancer, he told me he couldn't imagine being with anybody else, that in his darkest hours, I was the person he wanted to hold close. That he wanted to "die in my arms." So, we got married, and I dedicated everything I had to him: nursing him through his illness, helping him with his pain, and supporting him mentally throughout chemotherapy and radiation treatments.

Wanting to be there for him in his time of need, I put my whole self aside, pushing it into a corner in order to make enough room to address all his pain and needs. I didn't realize it at the time, because I was so focused on taking care of him, but by giving so much of myself to another, I was whittling myself away. It was a blessing and a relief to see him in remission for three years, although he passed away at the age of 36.

Similarly, in 2000, my father passed away from cancer, and, within hours of his death, my grandfather passed away from Alzheimer's. Although this was painful for me, I didn't grieve until a full year later. The reason for this was that these losses put my mother in a vulnerable state. She'd lost her husband and her father on the same day, and I wanted to be strong for her while she was grieving. What I didn't realize was that by prioritizing her grief, I inadvertently bypassed my own; there simply wasn't room for both of us to suffer at once, without the other's support. So, I put my emotions on a shelf, and it wasn't until a year later that I started feeling sad—out of nowhere, inexplicable emotions would balloon within me. One day at work, as my eyes welled up with tears for no apparent reason yet again, I checked the calendar and realized it was the anniversary of their deaths. It turned out there had, of course, been a reason for my tears. I'd just placed such a distance between myself and my grief that I couldn't even identify why I was crying.

I'm thankful for my psychology major, which helped me identify what was bothering me. I was worried my emotions may interfere with my ability to be professional, so as a precaution, I went to the doctor for further evaluation. This was a huge help, and I'm grateful that I'm able to admit to others when I need support; no one is immune to life's catastrophes, and everyone deserves whatever kind of healing may be of best use.

The key to supporting others without neglecting ourselves is self-awareness of our own limits, enabling us to set and maintain healthy boundaries. This can be challenging when the desire to help another person can be so strong and well-intentioned: we all want to be there for those we care about, and helpfulness is such a virtuous quality. When some people are going through a crisis, they may need more than it is reasonable of others to give. Of course, one can't set healthy boundaries without the self-awareness to know what one's limitations are in the first place.

A well-intentioned close friend of mine—who is generous with her attention and has a big heart—used to have the habit of listening to everybody's problems, providing comfort. She never had issues with anxiety, until one day, while she was driving, she had a panic attack in her car. What she hadn't realized was that all those years of soaking up others' problems, like a sponge, had taken a toll. By trying so hard to listen and offer support, she'd been unknowingly internalizing everybody else's pain, surpassing her emotional threshold. "Secondary trauma" is the impact of another person's trauma, on you, tangentially.[3] So simply by listening to too many other people's stories, my friend was beginning to adopt some of their symptoms of PTSD.

She's still struggling to recover from the impact of this, but I'm relieved to see that she has begun setting boundaries with those around her, kindly requesting that they not describe their problems to her. The earlier we can self-identify our own limits, the easier it will be for us to set healthy boundaries with others later.

On the other side of this spectrum are the many people who could benefit from learning to be more generous listeners, offering a compassionate ear to those struggling when they have the bandwidth to do so. Going through fertility challenges has been stressful for me, and the ability to discuss my feelings about it—honestly and openly—with others would have made a big difference in my coping skills. I'm grateful to those who have simply given me the space to express my thoughts and feelings without question or judgment, but at times, in their eagerness to help "solve" my problems—rather than simply allow me to share them—some people can inadvertently lapse into advice-giving, which detracts from my ability to express myself openly. They may urge me to take one course of action or another, inserting their opinions onto my already layered feelings. This can be hurtful and disappointing, because you may leave conversations like these with your problems weighing more heavily on you than before.

When people open up, they rarely want specific advice, just the warm permission for their problems to be voiced and received. Over the years, I've learned to choose my topics carefully, making sure I'm opening up with people who are in a good place to receive my feelings, and I'm fortunate to have friends with whom I feel I can share anything.

[3] NYCU - Jan 2020 - Combined Handout _ Questions

It's a beautiful thing when we can give to others, just be sure that you are giving to healthy causes; otherwise, you can find yourself becoming drained and lonely. My personal belief is that everyone who comes into your life does so for a specific reason, at that specific time. Ask yourself, *what purpose does this connection have in my life right now? Why have I been offered the chance to help this person on his or her journey, and is my generosity reciprocated?*

———— ✺ ————

If you're wondering how to scale back on the time you give to a person in need, just check in with yourself every so often. Don't be afraid to take a sick day or spend some time with family. Prioritize alone time so you can identify when, and in what ways, you may be stretching yourself too thin. Don't just monitor your thoughts and feelings, check in with things your body may be trying to tell you. If you're starting to experience symptoms similar to those for whom you're caring, that could be a sign you've taken on more than is healthy. Disharmony between the mind, body, and soul could suggest a difficulty coping.

Another trick is my favorite word: "no." Many people don't know how to use this word, it seems, but I take joy in it. When I politely but firmly say no, I am setting a boundary. No one can hurt me when I do this, because once my boundary has been established, the other person can either take it or leave it, and that's their choice, and they have full ownership of whatever reaction they may have to it.

There was a time when it felt like every week, someone was calling me to get me to join a new group, take on some leadership role, or volunteer for something. I enjoy service and collaboration, but at a certain point, it can steal time away from your self-care that you can't afford to give up. Because my time is the more precious commodity, not to be handed out too freely, I have learned to prioritize. Time is not only the greatest healer of wounds, but it is also the greatest resource within the realm of self-care. Protect your time. You need and deserve it. You've got to "do you," balancing your compassion with your sacrifices.

Lately, if I'm asked to partake in something that I don't have time for, I'll use a harmless and generic excuse, such as "I'm not available." My husband, on the other hand, struggling

with the guilt of declining a request, will go so far in the opposite direction that he invariably draws *too* much attention to his alibi: "Sorry," he'll say. "I can't, I'm going to Africa." Then, understandably, everyone grows excited and wants to learn all of the details about his trip, causing him to squirm under pressure. For his sake, I hope he upgrades his excuse soon!

I know firsthand how challenging self-awareness can be. There have been times when I've simply locked up my pain in a tiny box, and then thrown it—and the key—away. Often, I even lose my actual memory of the details of the experiences I've survived. This has been one of my coping mechanisms, enabling me to stay strong, be positive and present for others, and succeed in managing others at work.

When my husband went through the grief of losing his son, I was glad to be able to be there to support him. But at the same time, so much of me was invested in his pain that there wasn't much space left over for me to mourn my own struggle with IVF—in a way, another loss of a child. But when the clinic contacted me, they shared this news with me bluntly, without compassion or warmth. It was as though they didn't appreciate what a big blow it could be for some clients. Instead of posting a complaint online, I called them back and encouraged them to treat other women's conditions with more sensitivity. Staff in these kinds of positions owe their patients better care.

Meanwhile, I didn't discuss my own pain with anybody; instead, burying it quietly away and busying myself in other things. This was difficult, but I also recognize how fortunate I am to have faith to lean on. My husband and I still want to have children, and we're going to continue to try, but if it's going to happen, then it's going to happen. If you're going to have faith, then you must have faith all the way. This helped me make my peace with our situation. At times like these, when I've struggled to get out of a rut, I've prayed. And in a way, I've felt as though I was handing my pain over to God, entrusting Him to hold it for me.

While I've cared for others, perhaps God has been a kind of caregiver to me, consistently present and encouraging me to get out of my rut and come back to life. God bless all

the caregivers and supporters who do not receive the thank yous, the accolades, the *I love yous*, etc. that they deserve and may need. And yet, they continue to do a great job caring for the individuals who need them, nonetheless.

The truth is, there are simply times when caring for others warps our vision. We don't see ourselves as clearly when we are busy concentrating on others, and in these cases, we may even lose sight of our own emotions altogether. The other person's pain takes up our entire perspective, and our own needs are pushed right out of the frame.

The good news is that anytime our perspectives shift too much towards others, causing unexpected harm to ourselves, they can always be shifted back to a healthier focus. After my optometrist told me I was near-sighted, and I received my eyeglasses, I was so happy to be able to see better again, even if the purpose was simply to watch television from a distance. Beforehand, I'd felt as though I didn't even have a problem. And yet, as soon as I could see what lay ahead of me more clearly, I felt good! I found my joy in being able to see better. The same is true when we focus too much on those around us. We all deserve to maintain proper clarity on ourselves. And the good news is, whatever is broken can be fixed, as long as one is looking for a solution.

3

TRAUMA-INFORMED PERSON SUPPORT AND RECOVERY

In the caregiving field, when I'm first getting to know a patient, I don't just look at his or her physical condition.

Patients' conditions are important, of course. Their injuries, pain levels, prognoses, and many other factors all determine their lengths of stay with us, as well as the kind of care they'll receive. On the most immediate level, our goal is to help them become as physically well as possible.

But how do you know when someone is suffering in their mind and heart, as well? Individuals can feel the impact of a traumatic event either immediately following, or at any point afterwards, the event itself, and the effects of trauma can last a short or long period of time, potentially leading to health issues and making it difficult to function in day-to-day life. But, because each individual is different in the way they cope with traumatic events, the symptoms of trauma can be complicated to decipher.

Often, the person simply won't act like him or herself anymore. They may not want to socialize as much as usual, or they may seem less interested in their hobbies or belongings.

For me, the best indicator is when somebody has simply lost their true smile. And there are many ways in which a smile can disappear. Some people withdraw from the world, shutting down under pressure, because they need to quietly process everything. Others may seem anxious, sad, or aggressive, acting out in ways that can shed light on the pain hidden within their inner landscape. I've seen patients yell, curse, storm off in the middle of a conversation, close the door on me, and more. Many are kind people by nature, but their stress gets the better of them, and they lose control.

When a person is coping with trauma, so much of their energy is allotted to protecting themselves from further pain, and to processing their inner struggles, that there isn't much left over for tolerance. They may feel raw, as though their hearts are exposed and vulnerable, perpetually on the brink of their breaking point. In a state like this, the smallest things can push someone over the edge into agitation.

This can make the work environment sensitive and dangerous, despite patients' good intentions. Often, they're quick to make amends afterwards, surprised and abashed by their poor behavior. It can be difficult for them to separate themselves from their trauma—sometimes feeling ashamed, rather than seeing their behavior as evidence that they're struggling and an incentive to seek more support.

Along with mood and behavior, a person's physical health can reveal clues about their mental state, too. Perhaps they're inexplicably fatigued, not sleeping enough or sleeping way too much. Perhaps they're getting chronic headaches or have a major change in appetite. The immune system suffers a great deal under mental stress, so even something that may seem innocuous, like a cold that won't go away or a bad cough, can be your body's way of telling you you've reached your threshold, and it's time to examine your limits and take your needs more seriously. Often, these are messages from the body to the mind to slow down, prioritize self-care, or seek support from others.

Although it may sound obvious, another clue can be the way a person answers when you ask how they're doing. But this is not as straightforward as you may think. I've worked with patients who, when asked how they are, consistently respond with, "I think I'm doing OK," or "I think I'm alright today." If you only *think* you're OK, then you probably aren't,

and perhaps you could benefit from some more help. It can be hard to catch tiny details such as these, but they can be revealing.

Other patients go the opposite way, so overcome with stress that as soon as someone gives them an opening, they can't help but start pouring out their life stories. I worked with a patient once who would go into painful detail about her stress, complaints, and needs. The kinds of patients I've worked with tend to be coping with very challenging problems, and I can understand the instinct to share with others. It's also important that patients confide in us honestly about what they need to heal, and that we meet their reasonable needs. But venting *too* much can keep your focus on your problems, building a conversational space wherein they, and you, can wallow. Too much venting can also inadvertently push others away instead of bridging connections. With patients who take venting to an unhealthy excess, I find it best to redirect.

Most people who are struggling, I've observed, can be placed in one of two categories: those who seek attention in order to heal, and those who want to be left alone. Some people simply crave external support to recover from trauma, while others rely more on their own inner resources. But most of us can benefit from a balance of both, and the challenge is that when someone is suffering from PTSD, they may feel so disoriented that they don't even know what they need. As caregivers, it's important to determine which patient is which, so that we know how to help them establish healthy habits. Some patients we encourage to open up more about their pain; others we may encourage to simply say, "I'm fine, thanks!" when someone asks how they're doing.

I've found that the majority are attention-seekers, making themselves as visible to caregivers as possible. These are the patients who would appear in my office every day, always with a new complaint no matter how well their requests were being met. This doesn't come from a selfish place. People like this just crave external recognition as part of their coping process. However, like everything else, that external support must be offered in moderation, otherwise it can trap people in their problems rather than giving them the strength they need to take ownership of their own recoveries.

The key is not to judge the ways that a given person may be processing his or her trauma, but rather, to simply be aware and observant of each individual struggling, so that you

may honor the uniqueness of their pain and needs, enabling you to provide the kind of care that best suits them. This is the attitude at the core of trauma-informed care, a treatment approach that centers around treating the whole person, rather than applying one set of solutions to everyone you support.

———— ∞ ————

Whether caring for someone in your professional or personal life, remember a few basic principles. First of all, no one recovers overnight, so take baby steps. The more patient you can be, letting the little things go and remembering that it usually isn't personal, the better you can offer support without getting your feelings hurt or becoming frustrated. Don't take the process one day at a time—take it one minute at a time.

Also, give people permission to feel their feelings and express themselves, even when their behavior may seem unusual to you. If they need to scream, let them. If they need to cry, don't judge the tears, just allow them. Whatever they may need to do, as long as they aren't hurting themselves or another person, let them. Carve out a wide arena that they can maneuver freely throughout. This is a way of saying to them, "I've got your back," so you can still be present for them without drawing negative attention to their behavior.

This doesn't mean staying in the other person's private space at all times, responding directly to their every whim. Everyone needs space, and nagging or nitpicking at someone isn't going to expedite their healing; it's likely going to make them feel invaded, or, worse, make them grow dependent on your support. Healing can't be rushed to suit anyone's convenience, so as much as we hope to see those we care about get better, sometimes the best thing we can do for them is decide when to be by their side and when to leave them alone so they can express themselves, collect their thoughts, and utilize their inner resources. Indeed, though it may sound counterintuitive, backing off is part of the language of support. And eespecting others' privacy is a way of being present for them, of cherishing their ownership of their pain as well as their intimate sphere of healing.

The reason this matters is when you don't take the time to understand someone, or when you attempt to provide a blanket form of support to each person in need, then you can slip into some harmful mistakes, hindering the healing process. You can find yourself

making assumptions based on stereotypes, judging a person's problems instead of seeking to comprehend them, or perhaps even blaming them for their struggles.

I met a woman who had experienced knee injuries, and many had a perception of her as someone who was at risk for developing a substance addiction. However, after getting to know her better, I learned that she had been involved in an emergency plane landing on 9/11. Exiting the plane, via a shute, had harmed her knee, giving her some pain and difficulty with mobility. But the real source of that pain was a far deeper trauma with roots connected to her sense of safety and security in her home country, and while traveling. The same woman, it turned out, had also been sexually assaulted by her partner.

This kind of individualized knowledge is what makes it possible for caregivers to be sensitive to the full spectrum of others' pain. It also enables caregivers to avoid making comments or taking actions that could cause the patient to relive their trauma all over again. Most importantly, it informs the kind of care they should receive, so we can tailor our strategies to suit patients' individual needs, preventing them from lapsing back into traumatic memories.

I did something similar at home. After my husband's son was shot, I used to make sure to avoid any movies or TV shows that featured gun violence. Since I understood what was behind his exterior—the root of his pain—I was able to do my best to avoid inadvertently triggering his memories of it.

Central to the trauma-informed care approach is helping survivors rebuild their autonomy. This can be challenging when many people hesitate to openly discuss their trauma. Some may be afraid of judgment; others may struggle to trust their listeners. Many feel a sense of shame as a result of the traumatic incident, and some may even be concerned for their own safety. When a person opens up to you about their experiences, try to remain matter-of-fact but supportive. Respect the person's personal space and help them feel comfortable by matching their body language and volume of voice. In any kind of setting, though, when someone initiates a sensitive discussion about their trauma, exercise compassion. Try to avoid appearing aggressive or agitated. Focus on their current state

of being, as opposed to the source of their trauma. Do not judge or stigmatize their experiences. Find a healthy balance in reacting to what they share with you, so that you neither overreact or underreact to their pain. As you listen, don't lose sight of your own triggers, limits, and needs. Let the other person guide the conversation, giving them as much control over the discussion as possible, within the parameters of your own healthy boundaries.

I can't overstate the significance of simply listening. I'm pleased to be nicknamed "The Fixer" at work, going out of my way to offer a shoulder to lean on to anyone in need. If a person leaves my office feeling better than they did when they came in, then I feel as though I've done my job, and I can sleep well at night. Listening is of the utmost importance within nursing home administration, where some of the most challenging conversations of people's lives take place: whether a person's stay will be short-term or long-term; whether they may regain the ability to walk, the ability to swallow; whether they will ever to return to their former, "normal" lives.

Mixed in with all of this is the fact that every person has his or her own culture, history, religious beliefs, issues with gender identity, and perceptions of healthcare, etc. These enriching differences are at the heart of our plans of care for every patient. The idea is not to make assumptions, but to always be on the lookout for ways to respect others' cultural and religious heritage, as these play an important role in recovery and give caregivers the opportunity to show respect. In some cultures, community and family are seen as integral components to the healing process, which could create a challenge for individuals recovering alone. Other cultures stigmatize trauma, potentially making it difficult for those struggling to speak openly about their problems, although they may feel comfortable writing about it, for example, instead. Some patients, due to their cultures' associations or beliefs, may be reluctant to take medicine, putting them in greater pain.

Many, I've learned, would rather pass away than accept a prescription that could save their lives or reduce their suffering. For some patients who are at risk of passing on, we are often requested to place them in beds right beside a window, so that upon their deaths, the window may be opened. This is important to their faith, and if we fail to do this for any reason, then the impact can be devastating on their loved ones. My teams

and I have always been eager to oblige, so we can respect these patients' dignity, even after their passing.

Key to helping others recover is knowing how to collaborate with other caregivers, exchanging mutual support as a team. So how can we best help each other help others?

If a colleague, or anyone you know, is experiencing distressing emotions, engaging in addictive or compulsive behaviors, feeling increasingly unsafe or helpless in familiar situations, or beginning to judge or blame the trauma victim whom they're trying so hard to support, then they may be neglecting their own self-care. This takes many shapes and forms. Caregivers may become too emotionally attached to the trauma victim, or they may become overly detached from him or her, seeking to avoid exposure to the trauma.

If your colleagues are missing a great deal of work due to health issues or showing a notable decrease in motivation, then this could be a sign that they would benefit from more support, themselves. I feel fortunate to thrive in leadership roles. Not only did I teach other children growing up, but as a professional, I at one point owned a nursing school, and it brings me joy to know that I was partly responsible for the training, licensing and certification, and now, the active careers of hundreds of nurses. Within my current job, I frequently train our staff and act as a leader to the rest of my team. I pride myself in staying strong and making tough decisions, always doing my best to block out what others may think of me as a person.

When it comes to managing others, I have a slogan: trust no one, delegate nothing, and follow up with everything. I learned this early in my career, and it's become my anthem. It means trust your colleagues but supervise their work and always verify that they actually did it. That way, you can ensure excellence. Perhaps this could be the subject for another book someday. As a leader, always remember the example you set for your team. Watch them in action so you can relate to what they go through each day. Seek to understand what they are experiencing and advocate for their needs. Be compassionate with them, as one would be with patients, to help them feel respected and important, and give them

permission to speak up about their difficulties. A positive and collaborative team, indeed, promotes healing among patients.[4]

I'm grateful for the colleagues I've been able to work with, as their presence alone has helped me process the challenging work of helping others. But at times, I've wondered whether my colleagues understand the depth of my own pain—that despite my strong exterior, I am as vulnerable to trauma as they are, and as our patients are. This is the price tag that can come with seeking to be a strong role model; sometimes, you suspect that those around you don't glimpse the magnitude of your own human frailty, the one thing that unites us all. But of course, I go through trauma, just like anybody. We all do, and, if we're willing, we can all follow it back towards joy.

[4] NYCU - Jan 2020 - Combined Handout _ Questions

4

RECLAIMING THE JOY TO LIVE

Curiously, many people seem to be able to sense the timing of their own deaths. I saw this with my first husband, who always told me he would die in his 30s and died of cancer at the age of 36. I've also seen it countless times at the nursing home, where patients talk about the time when they suspect they'll pass away. Often, they'll mention it casually, as though it's a truth so deeply embedded in them, so apparent to their minds and bodies, that on many levels it's already something they've accepted. Other times, people will joke about it, perhaps not realizing the magnitude of their offhand remarks. It can be frightening and upsetting for others to hear these kinds of comments, especially given how accurate they tend to be. It feels to me like these people are sending negative messages into the universe, ultimately receiving their wish. So how does one send positive messages into the universe, instead? While trauma is as varied as each individual and circumstance, certain truths cut across all cultures. One of those is that at the heart of all difficulties, no matter the cause, there is always the capacity for strength, hope, and love.

Growing up, I was told that girls are to boys what matches are to matchboxes. In Haitian culture, parents tend to set extremely high standards for their children, and dating is treated as something so threatening that when I first started seeing boys, I was too scared to tell my parents. They believed that when young women went off to college, they'd return with a baby instead of a degree. The Haitian mentality is that you must make your parents proud and avoid any errors that could bring embarrassment to the family.

Under this amount of pressure and negativity, dating felt like it had to be a top-secret endeavor, unspeakable around adults.

When I started college, I rebelled against the high expectations I'd felt they put on me.

Liberated by my newfound independence, I got rid of all my skirts, went out and bought a pair of pants instead, and cut my hair short. Giddily, I marched back home from college, my appearance declaring, "This is the new me, and there's nothing you can do about it!" It felt wonderful—there's often a dose of joy tucked away inside of healthy rebellion.

Another way out of the pressure to please my parents was to become a high achiever, doing really well at school and work. Instinctively, perhaps as a response to their negativity towards dating, I grew to be more focused on building a career than on building a family. I wanted to get to the top and be successful, and for a long time, having children just wasn't a part of that equation. However, this kind of coping mechanism can be taken to an extreme. In retrospect, my goals could have benefitted from more balance, but it's only recently that my views have shifted a little bit in this area. With my professional success, I've come to appreciate the value of being a mother to children of our own, and my husband and I are still hopeful in this regard.

For many people, when something traumatic happens, they turn inwards—folding themselves into their pain and suffering. Acknowledging and focusing on one's pain is often a healthy and necessary part of healing, but it also puts a magnifying glass on one's heartache. Personally, I've found that getting outside of that inner darkness, rather than going deeper into it, is the more effective way to recover. When I'm hurting, my instinct is to go outwards, into the world at large. I connect with others, diving into my passions. I throw myself into enjoying life. I've found that busying myself with things that bring me pleasure is what shrinks my pain down to a more manageable size.

After going through the experience of dealing with a loved one with cancer, it could have been tempting for me to retreat inside myself, caught within the orbit of my pain. But this isn't like me. Instead, I did the exact opposite. I started going ballroom dancing.

Going out and being social tapped into my extroverted nature, and it brought me out of my mind, freeing me from my negative thoughts. I'd lose myself in the rhythm of the music, feeling my body relaxing into the fluid motions. Ballroom dancing rewired my brain, breathing new life into me. I felt brand-new, even fantasizing about being a dancer in another life, an idea that brightened my spirit. Gradually, my passion grew to include salsa and other kinds of Latin music, and I made some wonderful connections with people, all through the simple act of coming together each week and moving our bodies to the same choreography. It was as though the joy was there all along, both within me and around me, and ballroom dancing was just one of many mediums through which I was able to tap back into it.

I've brought this same spirit—simply getting up and getting out—to other areas of my life as well, and it's helped me to stay strong and positive at critical times. In my experience, and through my observations of others, I've come to understand a definition of joy as anything that grants you an escape, anything that brings you relaxation and relief from pain and that makes you smile. Not a forced smile, like the kind I'd been seeing on my husband's face these last couple of years. But a smile that comes from your heart. That's the kind of smile I'd like to see in him more and more.

Joy is unbelievably accessible, because it's all around us. No matter our locations or circumstances, joy can be in the everyday, the simple, and the mundane. It can be so small scale, in fact, that we can be blind to it, missing or neglecting it. And, because it can be as unique to every individual as trauma, it arrives for us in a variety of shapes and forms. Just as those with PTSD have their own individual triggers for pain, they also have their own individual triggers for joy, and it's comforting to know that we can tap as easily into one as we can into the other, as long as we stay aware of our, and others', triggers: the good and the bad.

I worked with a patient once who was acting out. He would become agitated, throwing fits and even pushing people. The more aggressive his behavior grew, the more concerned we felt about safety. One day, his brother came to visit and assured us that this patient was really a gentle man, he was just burdened with too much stress. "Anytime my brother

acts out like that again," he said, "just start talking about old movies or Frank Sinatra. He'll snap right out of it."

This may sound too simple to be true, but we took this little tip very seriously. It was an excellent means of individualizing the patient's care, so we put it into action. Sure enough, when we started dropping these kinds of references into conversation, this patient's behavior changed. Such was his love for old movies that the mere mention of them could reel him back from his pain and tap him right back into the years-long joy he'd always felt when discussing Frank Sinatra.

Another time, I was on the phone with a colleague, when he disrupted the conversation and remarked, "Sorry, I'm just in the middle of catching a fish, could you hold on a moment?" It brought me so much joy just hearing, through the phone, about *his* joy, and I'm not even into fishing, myself! I could tell how much he was enjoying himself, and that escape just sounded so blissful. He was doing something he loves, simply because it makes him happy.

For my mother, it's going to church. Not just any church, but *her* church, which she prioritizes over all else in life. It's located an hour away, but she drives there every Sunday, rain or shine, because it's simply "her thing." Once, she even left the ER, because she couldn't risk being late or missing church by Sunday. We've discussed finding another church closer to her house, but she won't hear of it. It's what makes her happy, and that's that. Sometimes joy is blissfully stubborn.

In addition to ballroom dancing, another simple pleasure is getting my hair done on Saturdays. The sweet-smelling shampoos, the rollers, the blow-out... it sounds too small to be important, but that's exactly the point, that we don't need to go to great lengths to seek out joy. No matter what's going on during any given week, as soon as I have my hair done, I feel amazing, like a new woman! Healthcare facilities often provide patients with hairdressing services while they're recovering, and I've seen patients' entire moods change, time and time again, just in the simple anticipation of these visits. The patients will smile and perk up, looking forward to this reprieve from their trauma, and afterwards, they seem refreshed. At times, patients can feel less like their usual selves when they're recovering, partly since they don't look like their usual selves. This is fine, since their

priority is on recovering, but I've noticed that when people feel good about the way they look, they often feel a surge of confidence that can inspire them to get up and get moving. A bit of pampering is another way of maintaining people's dignity during difficult times.

This is a common result of joy, a boost in energy or a lifting of one's spirits. It isn't exactly ballroom dancing, but right now, my husband is finding his own joy by going back to graduate school. He's staying productive, becoming part of a cohort of others who share his academic interests and professional goals, and he's engaging with all kinds of new people. This is a positive development for him, because he's taking it one step at a time, and, little by little, the new and positive things in his routine will take up so much space that there will be less time for him to dwell on the bad.

Also, by the time he recovers from his trauma, he'll have made a tremendous achievement, which I hope he finds rewarding, and this will set a good example for his other children who are still alive and well. He'll be a role model for them, showing them how resilience can help you thrive in spite of tragedy. I believe that when a lesson comes from loss, that loss is not in vain. Joy often connects us with others, and those new connections take up space in our hearts, causing our own pain to lessen.

Other times, in the chaos of life, joy is found in the coziest and least active of places. For my husband and I, one of the greatest sources of joy is just spending time in bed. On Friday, no matter what's going on in my life, I don't want to hear it. It's Friday, the weekend is coming, and I cannot wait to go home and relax. I've become a homebody, energized by days of recuperation. On Sunday afternoons, for example, don't bother me between 2:30–5:00 p.m., as this is my sacred nap time. Everybody and their mama knows not to mess with me during these key hours. I learned the trick of Sunday afternoon power naps growing up, as a way to help prepare my body for school on Monday, and it's my way of clearing my thoughts and feeling calm before the week ahead.

My husband is similar. He is deeply grateful for the simple luxury and comfort that a familiar bed provides. "What would we do without a bed?" he always asks, perpetually

in awe and thankful. In bed, he is always safe and welcome. He can take a deep breath. He can sleep for days and not feel bothered, or he can lounge all day, napping on and off as he likes. He loves this sensation of not being bothered or rushed. Beds remind us that life is so simple at its core, and that there's relief and happiness in keeping life as easy as possible: just enjoying the household and the ways we spend our time away from work.

Recently, we celebrated Valentine's Day. I got home from work, and my husband shared the gift he'd gotten for me. We had some food. Not long after, he fell into a deep, comfortable sleep that lasted through the following morning!

There may have been a time when I'd have felt disappointed or annoyed. Many of us tend to put too much pressure on things like holidays, not to mention on ourselves and others. But instead of nagging him to wake up so we could celebrate in a traditional manner, I just let him sleep. It seemed to be what his mind and body needed, so I gave him permission to indulge. In the morning, I ordered breakfast to be delivered at home, and we ate in bed. He enjoyed it so much! Afterwards, we joked about how this was "the worst Valentine's Day ever," but the truth was, we both felt so loving towards each other on that day, and so loved. We didn't spend our evening waiting in a long line at a restaurant or pressuring ourselves to enjoy the holiday in some specific way. We didn't try to impress anybody, and the whole day was stripped of any expectation or pretense. We just stayed present for one another and allowed ourselves to savor the holiday in a way that made us feel content. Even laughing about how we chose to spend that Valentine's Day continued bringing us joy long afterwards, too.

This is central to joy: embracing the things you like without feeling forced or pressured. Most of us don't relax enough, and when we do, we give our bodies, hearts, and minds an opportunity to reset. My husband has had some major shocks in life, some real eye-openers, and yet, he's always there for others, giving and giving. At times, I can see his generosity leaving him with less energy than he had before, and I know that he can be at risk, like most of us, of overextending himself. This can lead to imbalanced relationships or burn-out, so any chance I have to help him escape into the simple comfort of lounging in bed, it's my pleasure to support him in taking it. Joyful mornings such as these are the kinds of mornings that I hope will help him come back to life.

My advice is, when you're struggling, give yourself permission to separate from whatever is bothering you. Pay attention to the simplest and most pleasurable activities available in day-to-day life and seize them, then let yourself delve deeper into them until your heart expands, and your smile returns naturally. When helping others, don't assume that one type of joy fits all. Take the care to learn about people, the kinds of things they love and value. Meet them where they are in those places and help them uncover and identify their unique sources of joy so that they may dive into them even more fully.

For one person, it may be meditation and deep breathing exercises. For another, it could be fishing. Maybe it's church, or salsa dancing, or having your hair and nails done, or going back to school or enjoying some social distancing. Whatever it is, embrace it. Encourage mindful and healthy activities, as being sober and fully engaged are necessary ingredients to joyful participation.

The point is, healing doesn't happen in a vacuum. It takes place through relationships, which grow when we give them plenty of time and action. This is what makes the caregiver-patient connection so profound, so complicated, and, at times, so very fragile. But remember that "relationships" can flourish in many forms. A healing relationship can be the relationship between a caregiver and patient, but a healing relationship can also exist between a caregiver and a colleague. Between a patient and a patient. Between a loved one and anyone in need.

A healing relationship can also exist between you and yourself, during a time of introspection and self-care. Or, it could be the relationship between you and your love for ballroom dancing, or for Frank Sinatra, or for fly-fishing, take your pick.

If you monitor all of these relationships and make sure that they remain as healthy as possible, then healing is just a matter of time.

40

5

CONCLUSION

For any number of reasons, many of us find ourselves in the position of being someone's caregiver at some time or another. Within those situations, we don't necessarily feel "called upon" to be there for the other person, we're just trying to do the compassionate thing within the context of a relationship that we value. When we love and depend on someone, we're simply seeking to maintain our happiness, via our connections to them. If the relationship falls apart, or if something goes horribly wrong in a situation, that's when we are in a position to search for meaning and purpose: why were we placed in these situations, alongside these fragile individuals needing our help?

You may, in fact, feel as though you were called upon to be there for some particular person in their time of need. I simply try to help others however I can, regardless of whether I feel called upon by some higher purpose or not. If you examine it closely enough, you can always find a reason or a lesson hidden inside of anything.

People say that caregiving is my calling. Although it can be extremely challenging, I love this work, and I'm grateful for the opportunity to lead and mentor others to succeed in this field. But I'm also very invested in my self-care and in my personal and professional growth, so I'm always looking forward to the next chapters of my life, embracing whatever challenges and meaning may lie in store for me and my loved ones, and this book has been a part of that. By sharing my experiences in caring for others, in all their painful and beautiful complexity, I'm moving forward from the challenges and bringing myself closer to all kinds of new joy, still yet to be discovered.

In wake of the current state of the world surrounding the COVID-19 pandemic, it is important to remember that life is so short, and we have to value every minute. If you want to do something, whether it's fishing or lounging in bed, then do it: at the end of the day, no one is coming to relieve my pain or make me feel better but God. It's just me, myself and I, so the most important thing I can do is have a good relationship with God myself, then consider my family and others next, and I choose not to waste an ounce of energy on those who don't deserve it, or they'll drain me. Self-love, family love, and simple joys. That's what this journey is all about. The best caregivers are self-carers: caring for themselves as much as they do for others.

Most jobs aren't easy. But the truth at the center of all of this is that self-awareness is a kind of medicine that works both ways. It keeps us mindful of our own needs and enables us to be fully present for others'. I love my husband so much, and I want to give him everything I can so that he remembers how valuable his life is, and how filled with happiness and wonder it still has the potential to be. But only God, and time, can turn that light back on within him, and that's OK. We all know our own limits better than anybody else does.

So as long as we do the best we can, set healthy boundaries for ourselves and others, and maybe go ballroom dancing when things get tough, then believe me. The *joie de vivre* is always closer within reach than it may seem.

49

SUGGESTED READING

DeCandia, C.J. & Guarino, K. (2015). "Trauma-Informed Care: An Ecological Response." *American Institutes for Research.* Available at: https://www.air.org/sites/default/files/downloads/report/Trauma-Informed-Care-An-Ecological-Response-Guarino-2015.pdf.

This article is an excellent overview of trauma, violence, and the evolution of trauma-informed care in the last twenty years. Areas the article addresses are: the evolution of trauma-informed care; awareness of violence & trauma in the lives of children, youth and families; neurodevelopmental & economic impact of trauma; ecological view of trauma & interventions; current models & practices; tools for implementing; key components of TIC; challenges in shifting models; discussion of evaluation of outcomes and next steps.

Printed in the United States
By Bookmasters